MW01537316

Sugar Skull Colouring Books for Adults

by Shut Up Coloring

Copyright © 2021 by Shut Up Coloring All rights reserved.

No part of this book may be reproduced in any form or by any electronic or mechanical means, including information storage and retrieval systems, without written permission from the author, except for the use of brief quotations in a book review.

This Colouring Book Belongs to

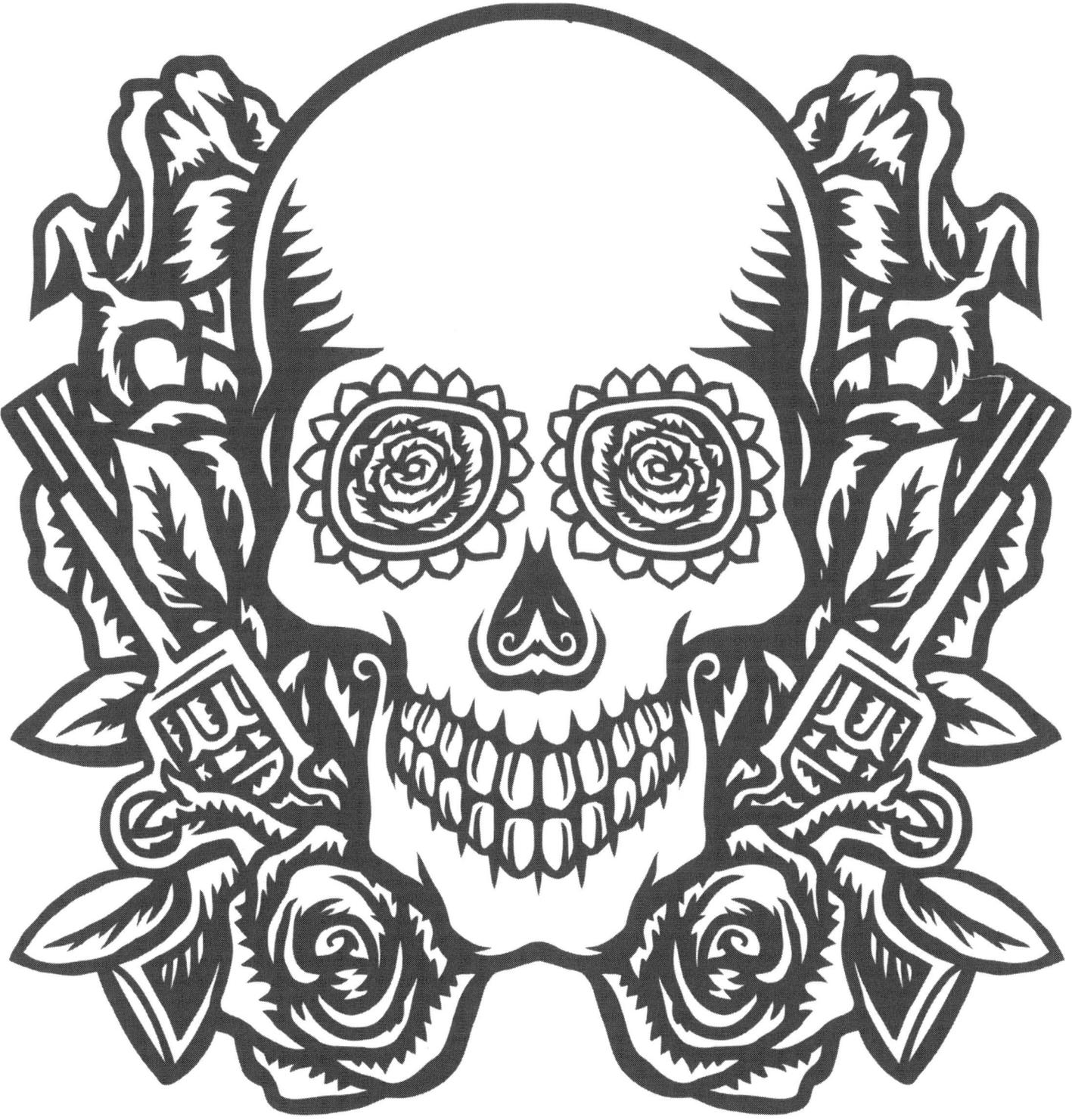

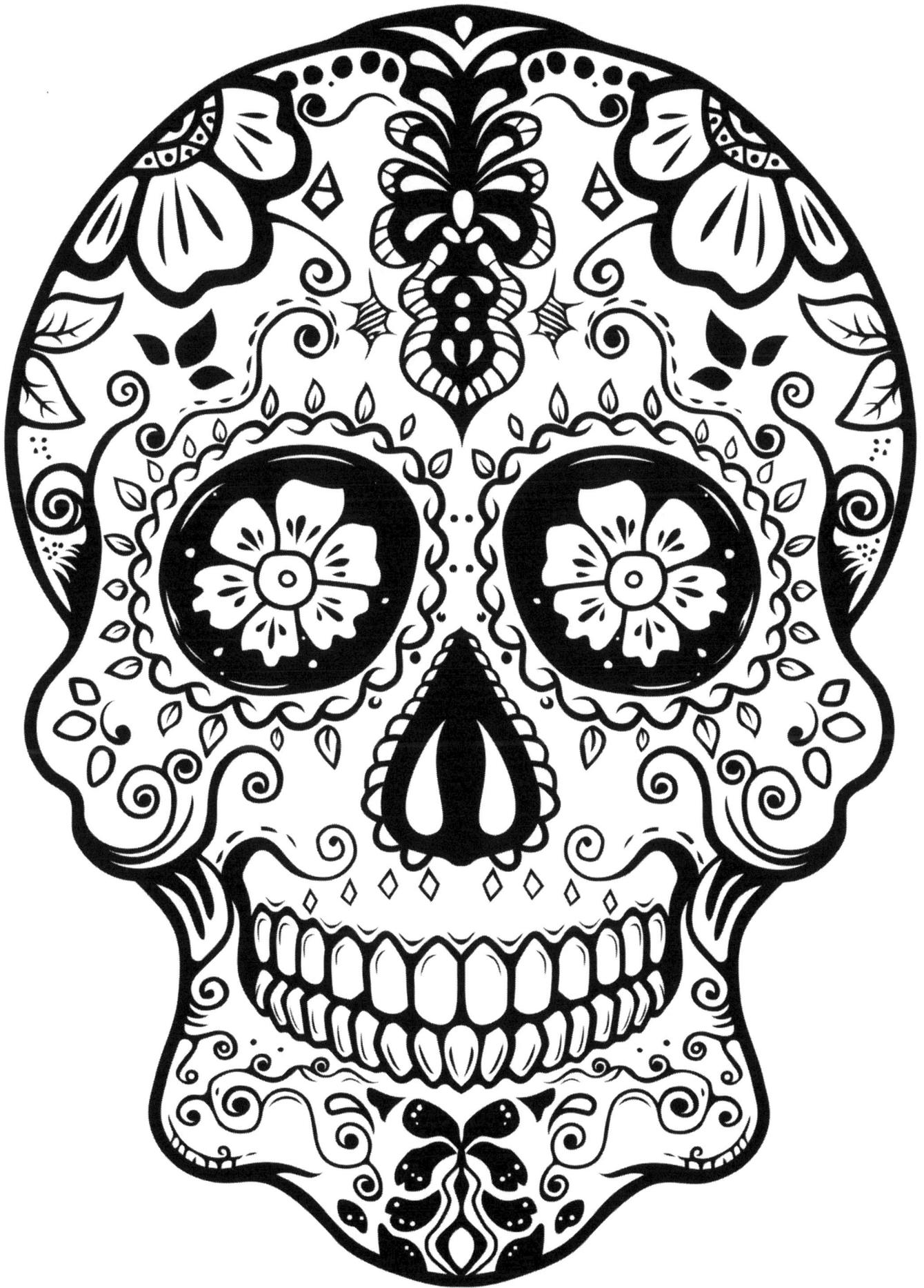

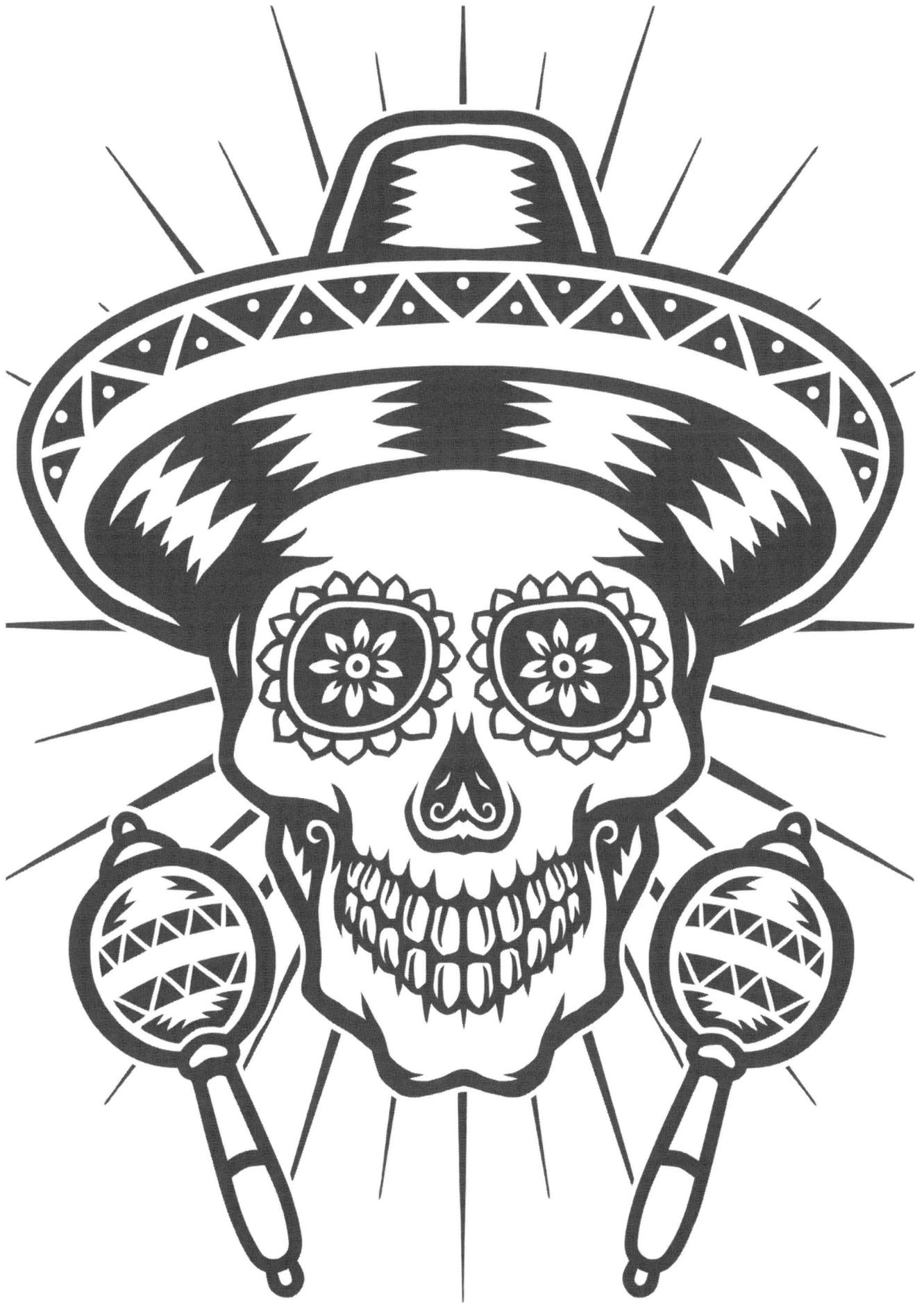

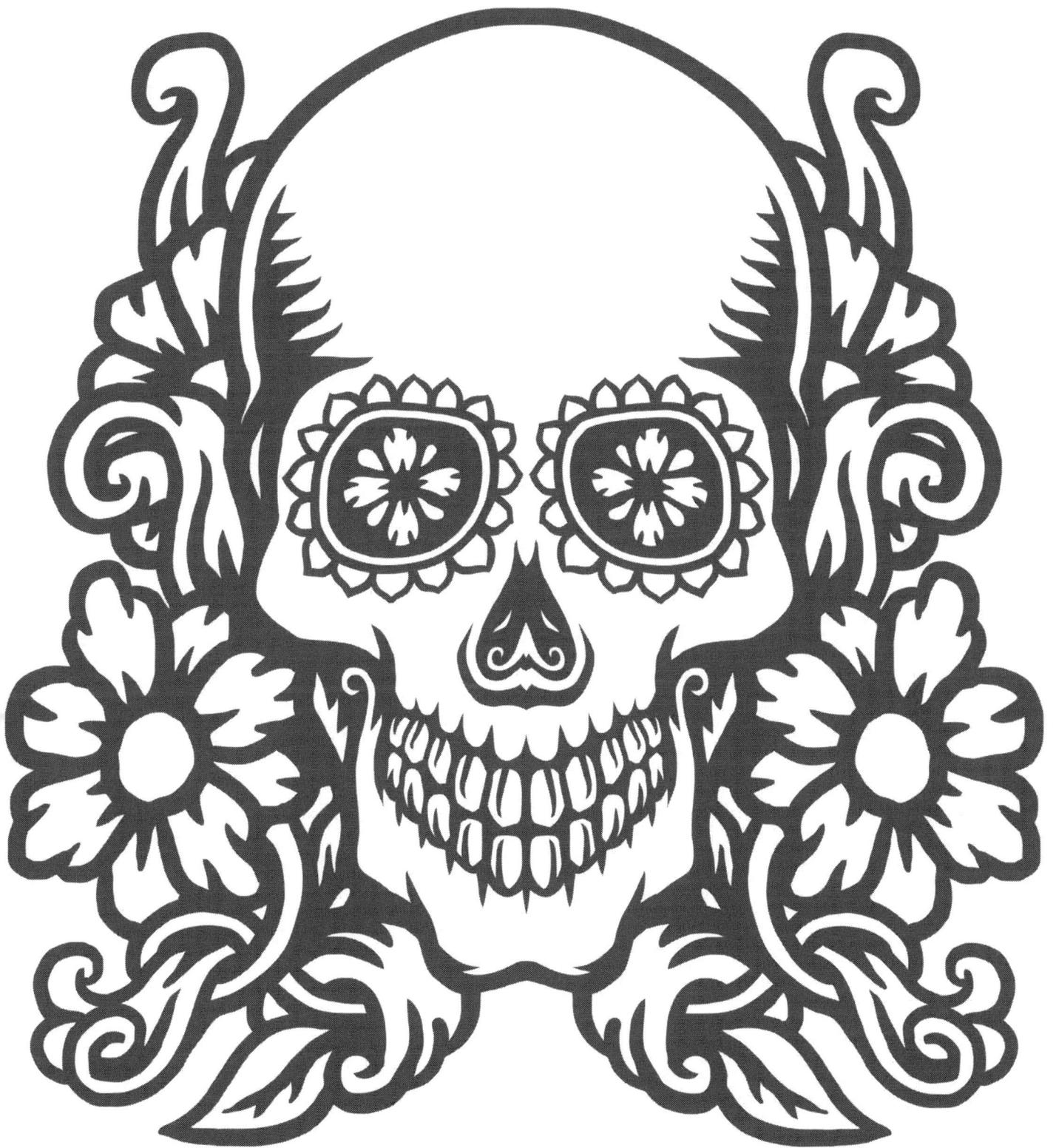

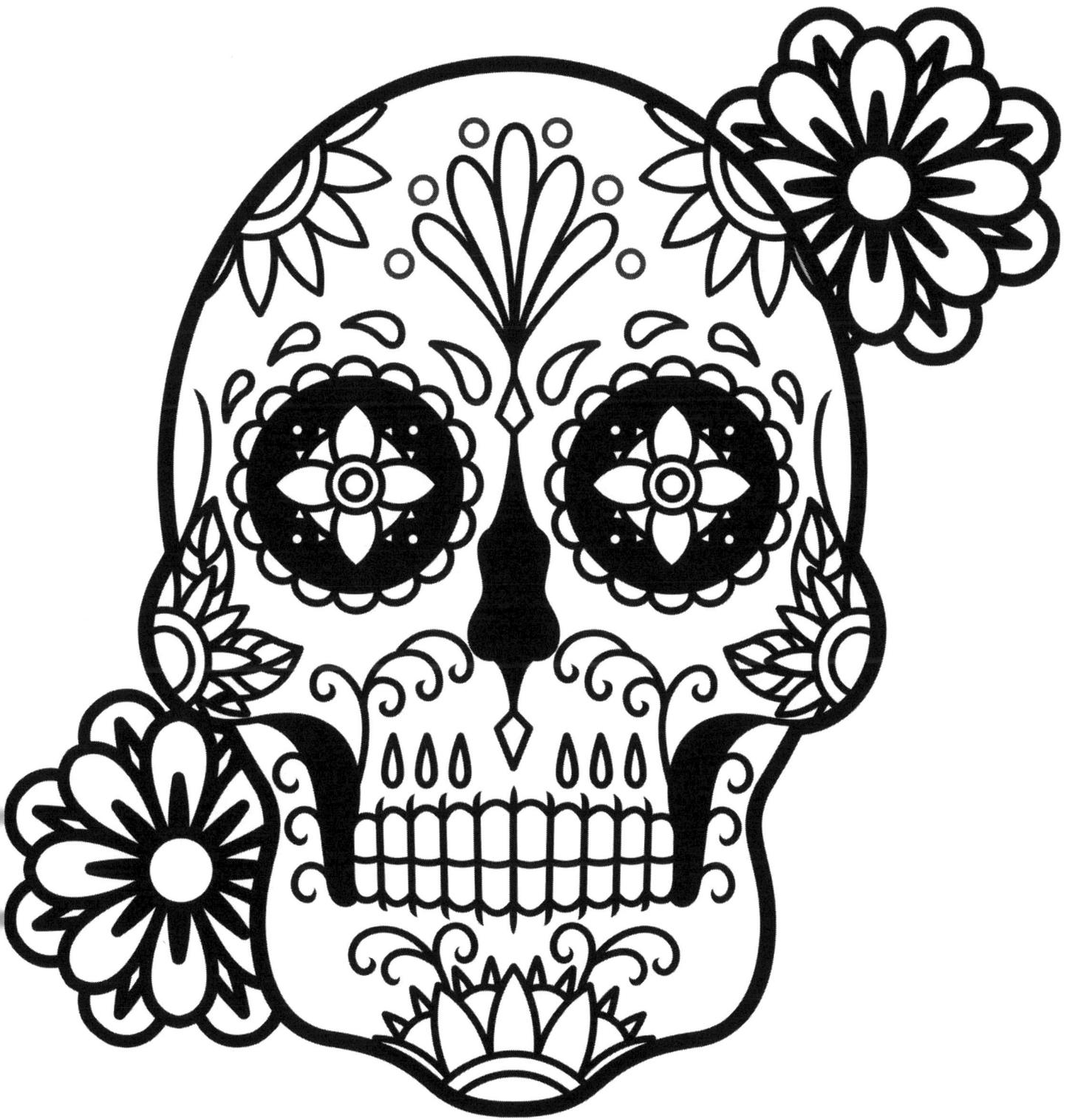

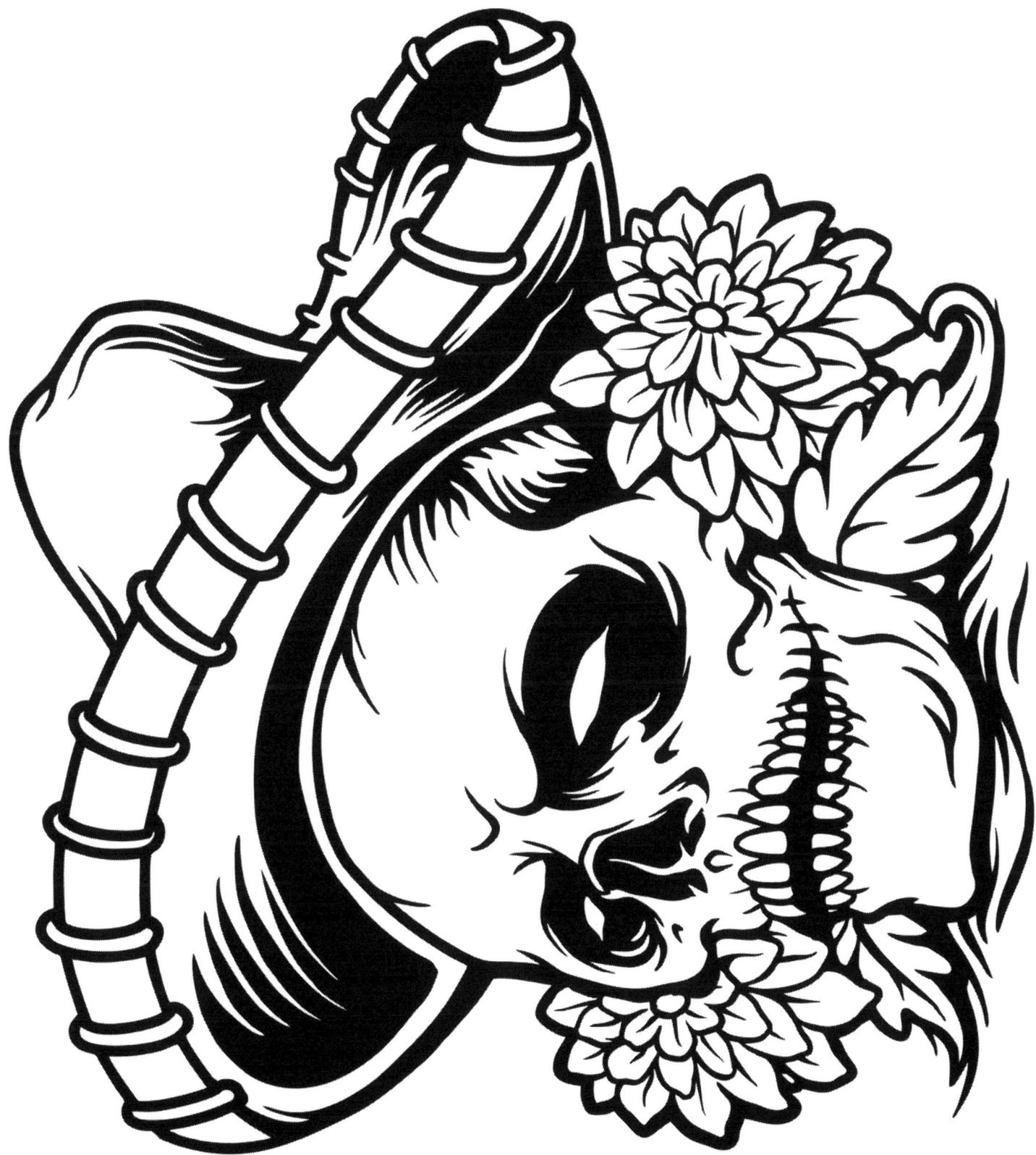

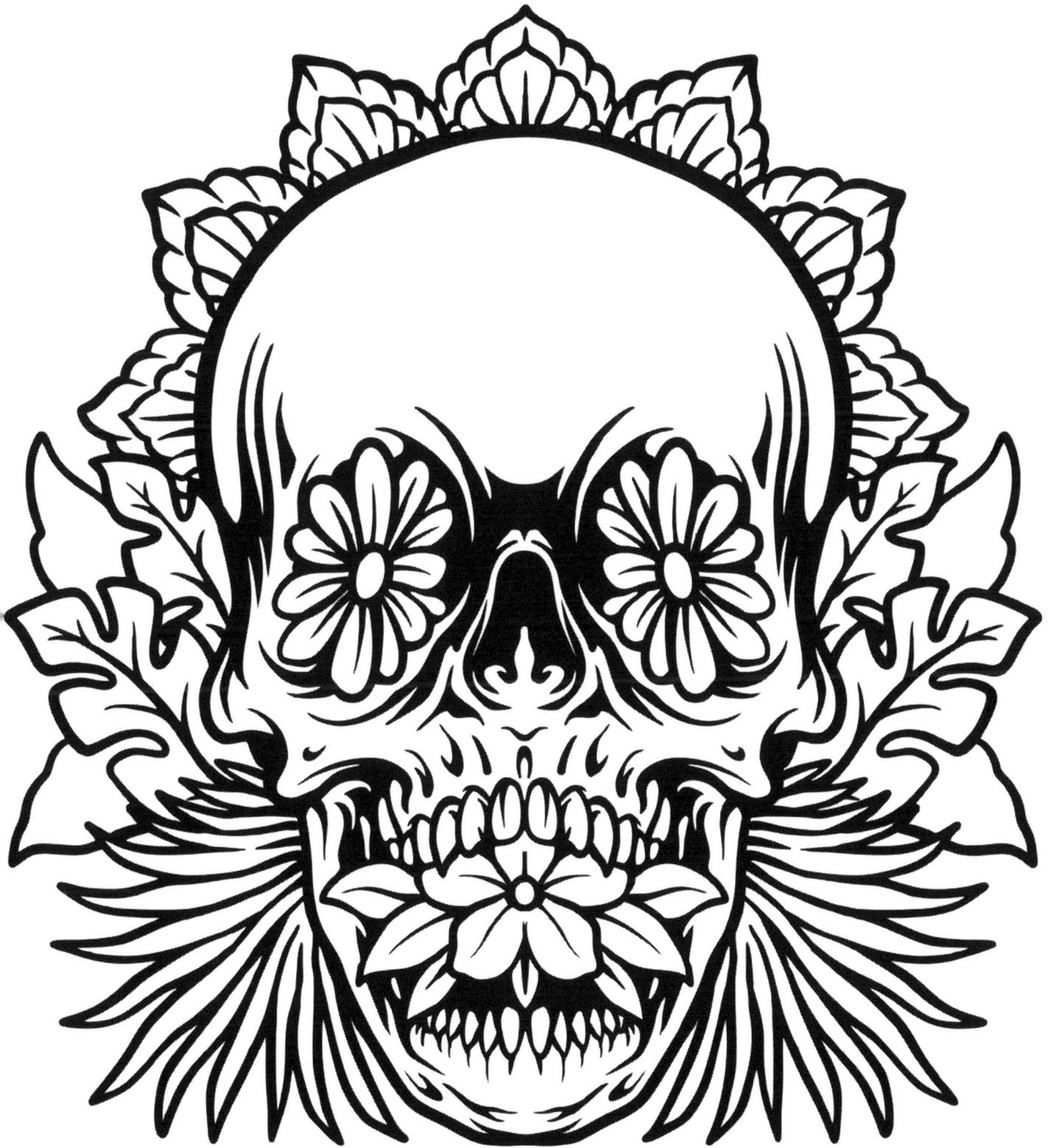

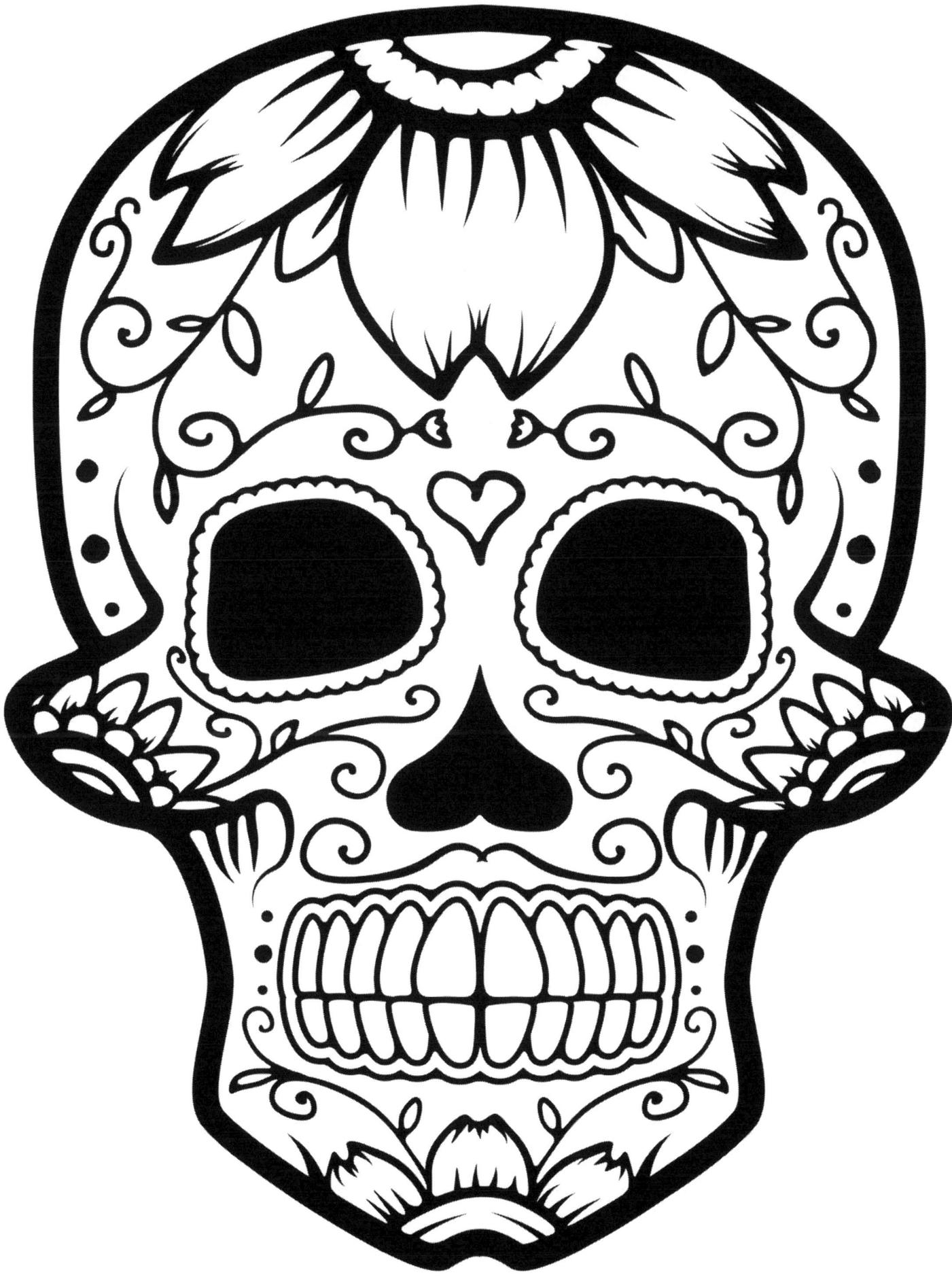

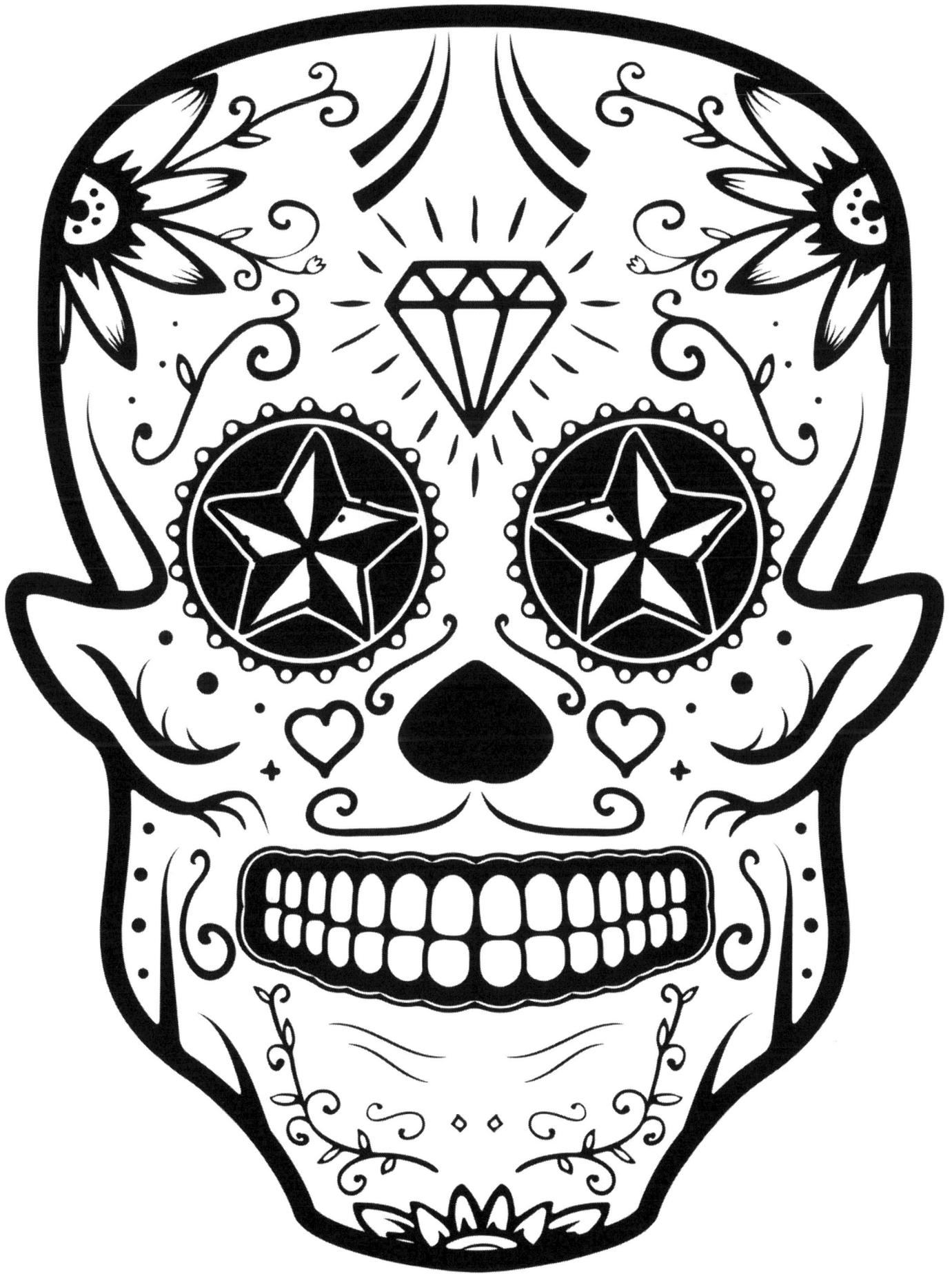

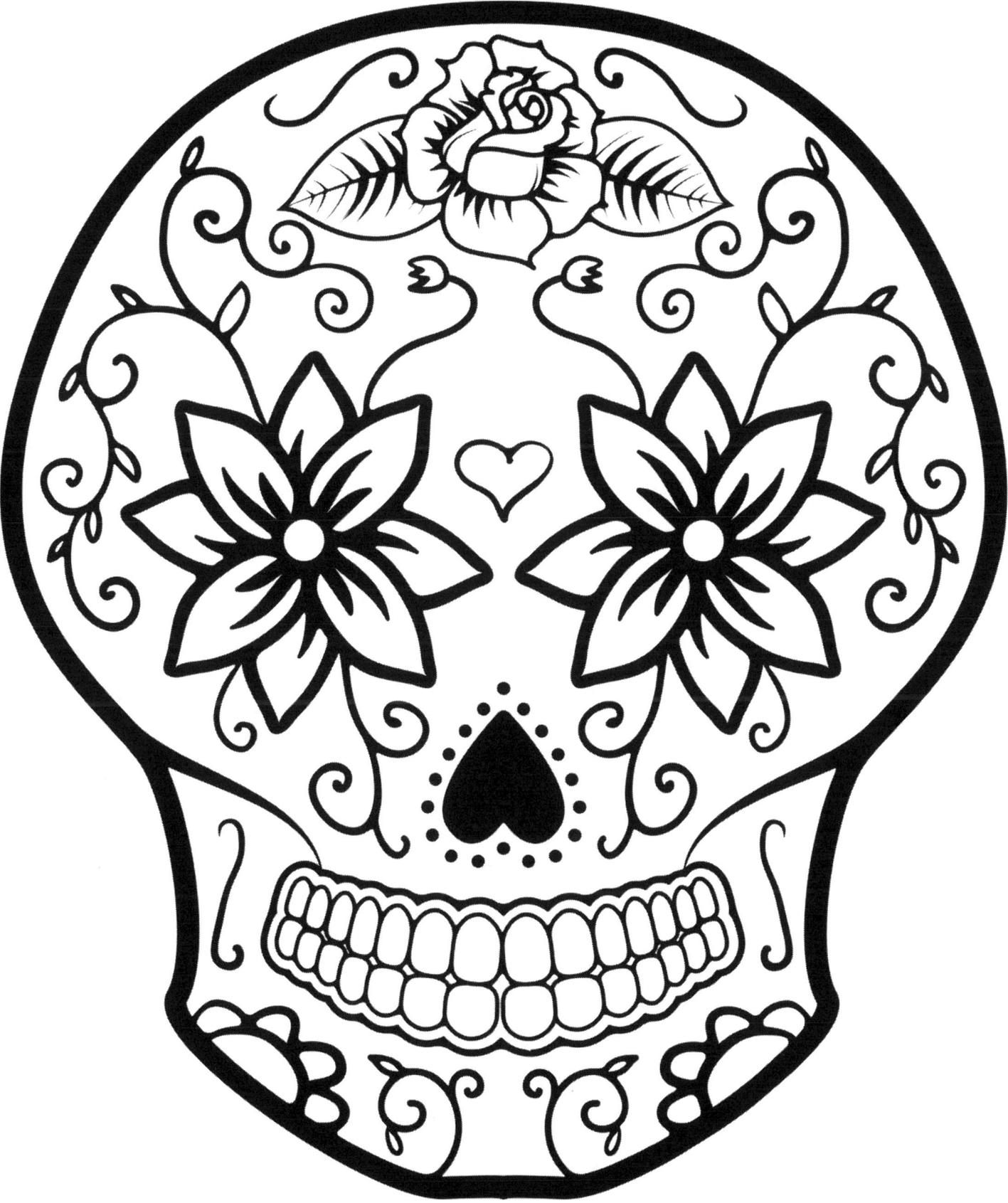

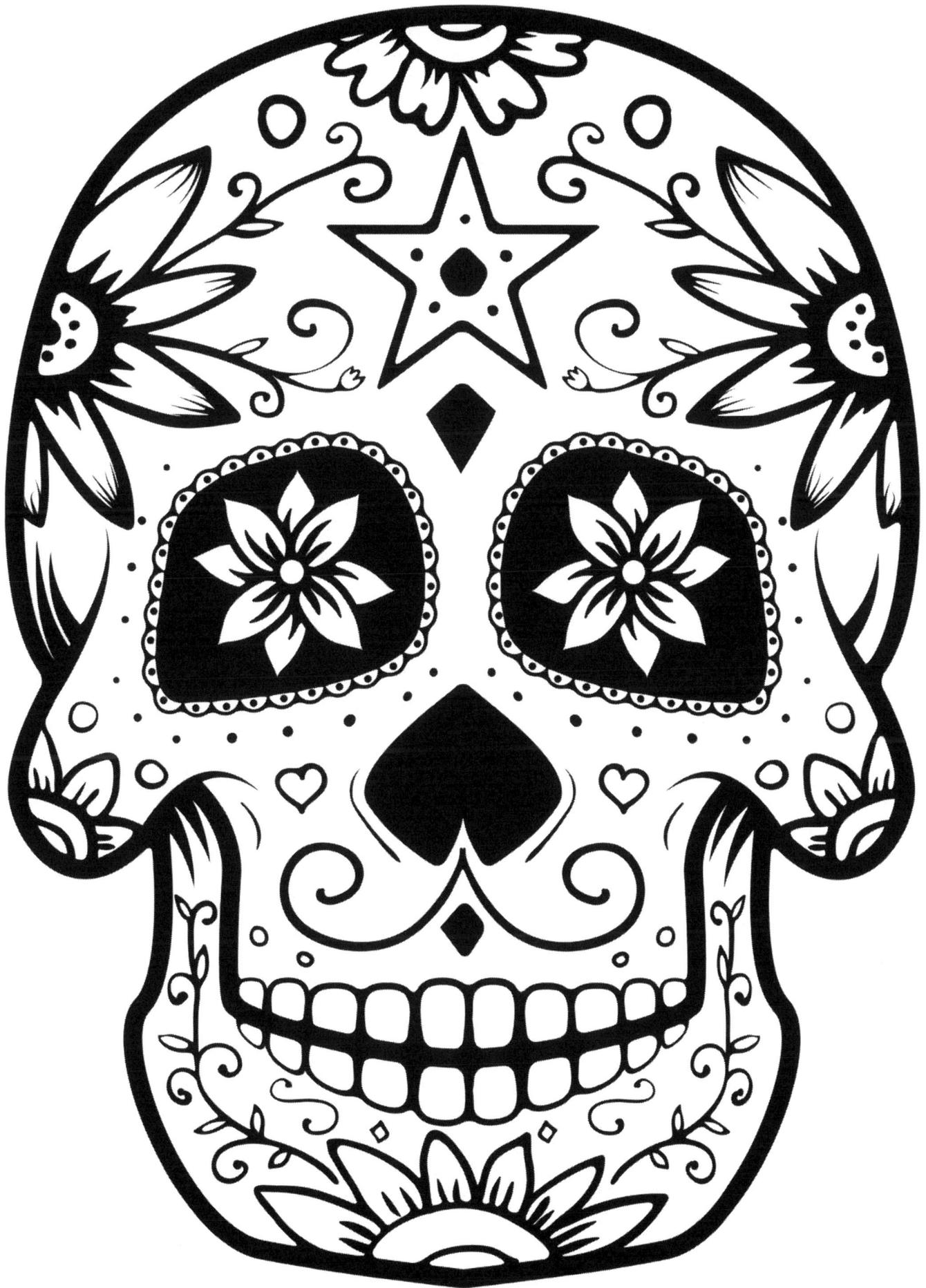

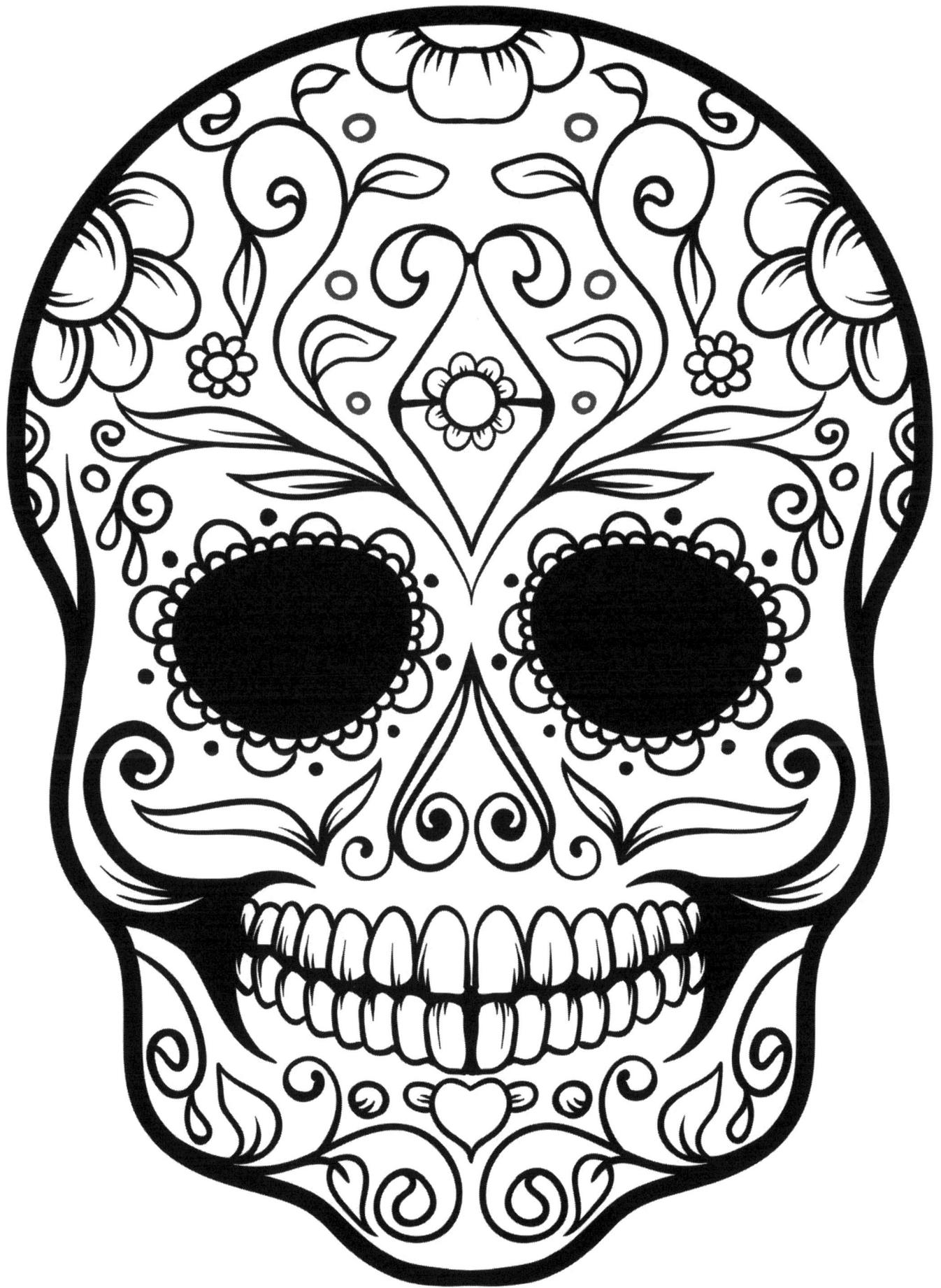

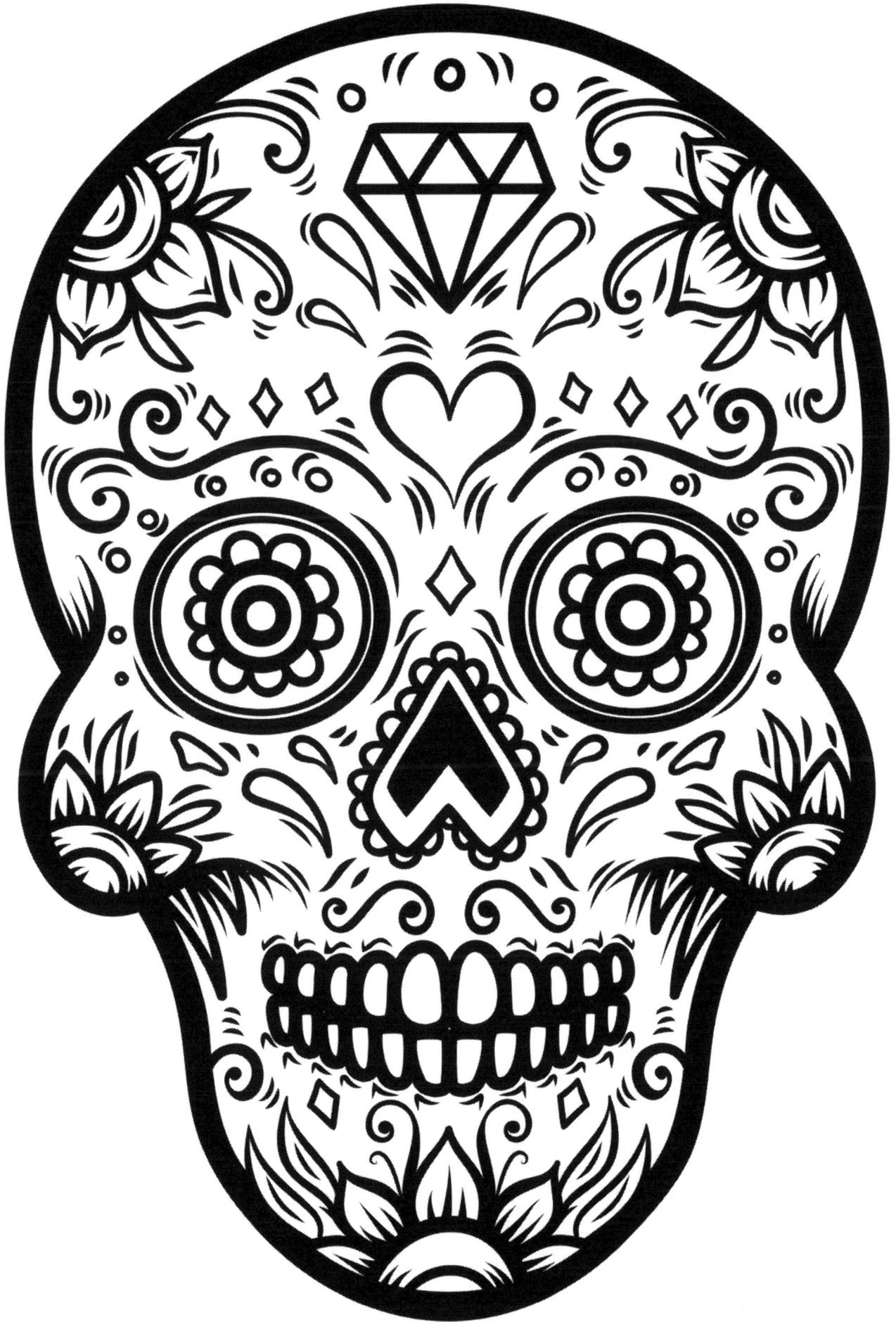

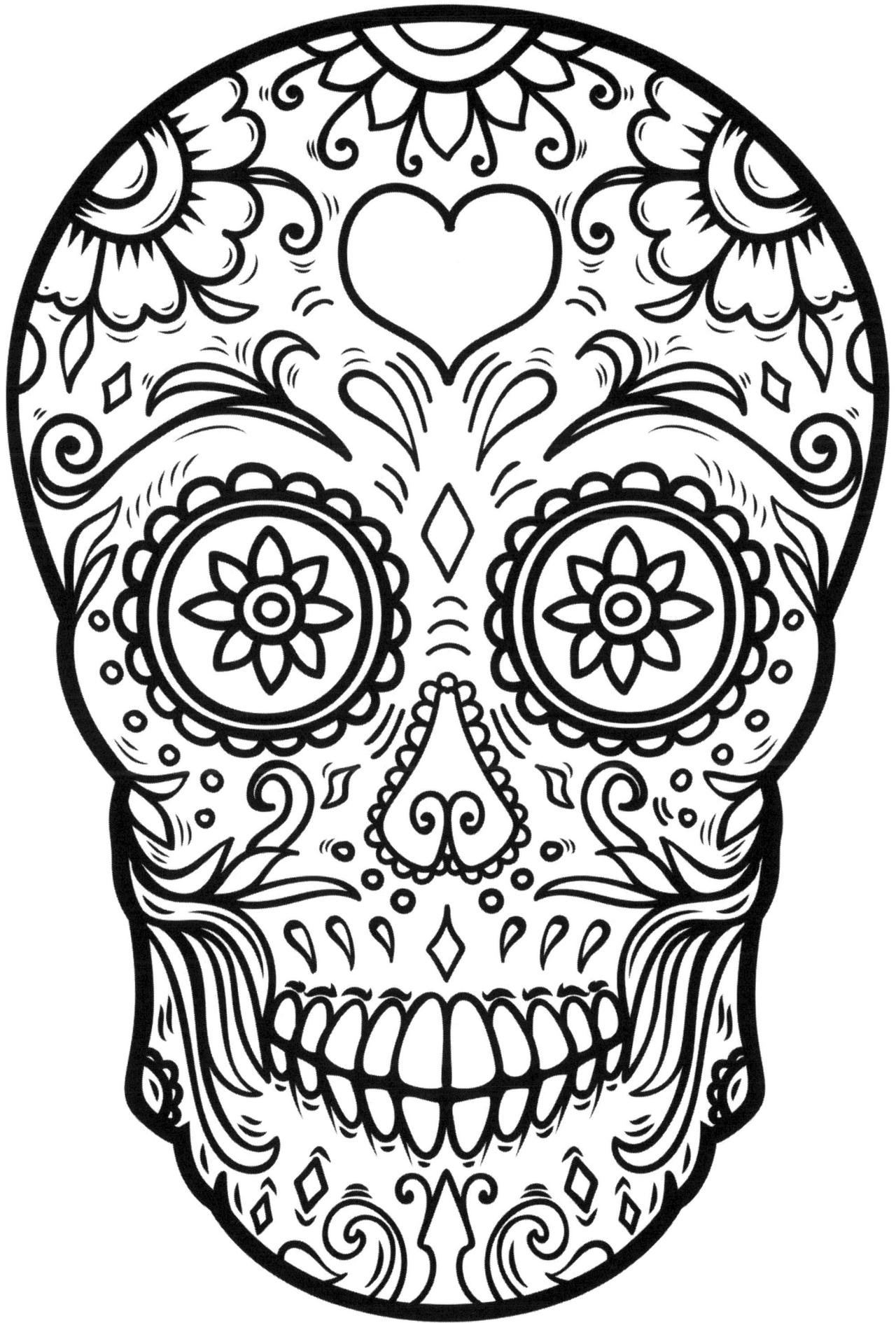

Made in United States
Troutdale, OR
02/01/2024

17369219R00038